# PRAYERS OF A CHILD

## Coloring and Activity Book

## NATALIE MAHNE

WESTBOW
PRESS®
A DIVISION OF THOMAS NELSON
& ZONDERVAN

WestBow Press books may be ordered through booksellers or by contacting:

WestBow Press
A Division of Thomas Nelson & Zondervan
1663 Liberty Drive
Bloomington, IN 47403
www.westbowpress.com
1 (866) 928-1240

ISBN: 978-1-4908-8625-1 (sc)

Library of Congress Control Number: 2015910179

Print information available on the last page.

WestBow Press rev. date: 06/24/2015

# "TAKE MY HAND"

Take my hand.
Take my hand and I'll lead you to deliverance.
I'll lead you to the holy land.
Take my hand and I'll lead you across the water.
Take my hand and we'll stick together.
Take my hand and you'll know I care.

Take my hand.
I'll lead you across the water.
I'll lead you across the sand.
We'll both travel together to the promise land.

We're headed across the river.
We're headed across the desert.
Take my hand and don't let go.
Just stare into my eyes and then you'll know that you're safe in the arms of Jesus!!!

TRACE YOUR HAND HERE IN THE SPACE PROVIDED.

# "HELP ME GET A LITTLE STRONGER"

I'm weak yet you're strong.
You pick me up when I fall.
When I'm thirsty you are my water.
When I'm hungry I look to your Word.

Lord, help me get a little stronger every day.
Pick me up in your strong hands to give me strength, hope, and faith.
Oh, Lord, I praise you every day.
Come pick me up in your hands and carry me away.

Color the hands and the watch.

# "WHEN I SEE YOU IN MY MIND"

When I see you in my mind, I see your wings of mercy around me.
I see your hands take hold of mine.
I see your face of glory.
I see your feet walk on water, and I see the world in your hands.

DRAW A PICTURE OF YOUR FACE IN THE SPACE PROVIDED BELOW.

# "WHEN I SEE YOU IN MY MIND"

# "YOU ARE MY EVERYTHING"

You lift my spirits high in my saddest times.
You give me hope and a life.
You lift me to the sky.
Soaring through the clouds, opening each door of creation.
You're the sunshine in the sky.

You are my footsteps of guidance. You are my eyes when I'm blind.
You are my ears when I'm deaf. You are my tongue when I can't speak.
You are my everything.

When the rain falls down and I hear the thunder and see a boom of light,
You are holding my hand all the same and all through the night.

When it's dark all around me, all the candles are burnt out,
All I can see is your hand touching mine.

PRACTICE DRAWING AN EYE AND EAR.

# "YOU ARE MY EVERYTHING"

You are my sunshine in the darkest times
You are my hope and life

Surely I may live but, open my heart to cherish
You're the one that makes my...

You mean more to me than life to a person in love...

When the moon falls and...
You are helping me...

...
All I can say is God...

# "HEAVEN"

There's a place farther than the stars and farther than the moon.

It's called heaven, a wonderful place.

You walk on streets of gold, beauty untold.

It's so heavenly there.

There will be riches and diamonds of kinds.

The most wonderful thing that is there is Jesus, the King of Kings.

It's so heavenly there!

DRAW A PICTURE OF HEAVEN IN THE SPACE BELOW.

# "FOREVER"

Forever He'll rein above showing His care and love.
Forever I will see that He is taking care of me.

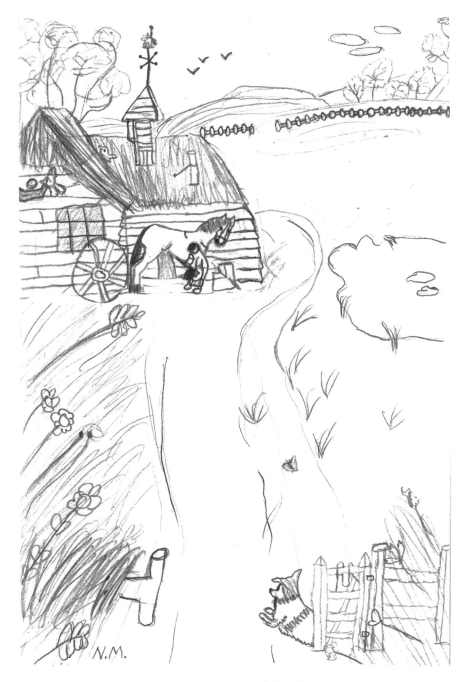

Color the picture of the farm.

# "WHEN I GO TO HEAVEN"

When I go to heaven, I know what I'm going to see.
The gates gold and bright, the clouds fluffy and white,
And the gates will open and the Lord I will see before me.
Lord, we praise you and lift your name on high.

DRAW A PICTURE OF THE GATES OF HEAVEN IN THE SPACE BELOW.
COLOR THEM GOLD OR YELLOW.
DRAW CLOUDS IN THE SKY.
COLOR THEM WHITE.
COLOR THE SKY BLUE.

# "IF YOU BELIEVE"

Sometimes you're lonely and sometimes people don't realize.

Sometimes you're put down or you don't know what to do.

If you believe then He will be with you.

He will pull you up from the ground and twist you the right way around

Because He cares for you.

If you believe He will carry you through.

COLOR AND PRETEND YOU ARE PLAYING THE GUITAR.
SING THE POEM LIKE A SONG.

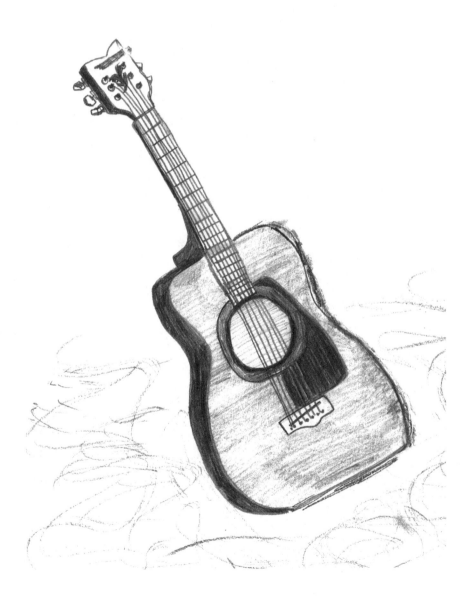

# "YOU ARE NOT ALONE"

When you're scared and you're not prepared
You can't see the light
Take the hand of the Guider
Behold Jesus

When you're alone and you're scared
Jesus will lead you home
He will guide your path
Don't be scared
You are not alone

When you think you're lost and on your own
Take the hand of the Guider
Behold Jesus

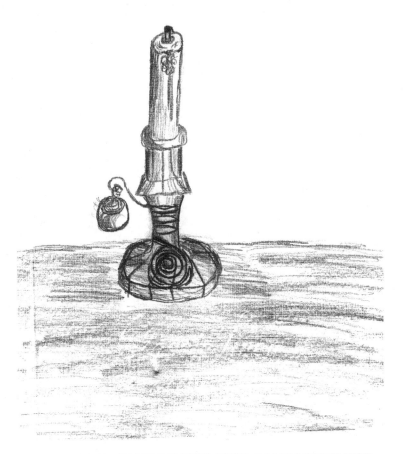

COLOR THE CANDLE AND THE CANDLEHOLDER.

# "WHEN I SEE HIM"

When I get to heaven, I'll see His face and feel the grace.
He will open the gates and I'll walk down the path so shining and bright.
I'll walk on the clouds so soft and light.
When I get to heaven, I'll rejoice in His Name.

COLOR THE TENNIS SHOE. DO YOU THINK WE WILL WEAR TENNIS SHOES IN HEAVEN?

# "LET THERE BE LIGHT"

Let there be light in the sky, Lord Jesus
Let there be light, oh Lord
Let us see the miraculous wonders and miracles and powers
You behold
Let there be light!

COLOR THE LIGHT BULB BELOW.
GOD'S LIGHT IS EVEN BRIGHTER THAN THE LIGHT OF A LIGHT BULB.

# "SHINE DOWN FROM THE HEAVENS"

One day I was sitting on the floor
Thinking about You
Wondering why or if I would ever meet you.

Lord, shine down from the heavens your wondrous light
Make everything everything so bright
Lord shine from the heavens your wondrous light
Make everything right

Stuck on the floor with nothing to do
I started to thinking thinking about You.

COLOR THE PICTURE OF THE CHILD AND THE LAMB.

# "THE VOICE OF AN ANGEL"

Look up high and you will find something greater than the stars
Something more powerful than the lion and brighter than the sun

You can hear the voice of an angel
The mighty blow of a trumpet
The eagle high in the sky and you can't see it with your eye
The only way you can see it is with your heart
It's heaven, heaven, heaven
I'll be there some day

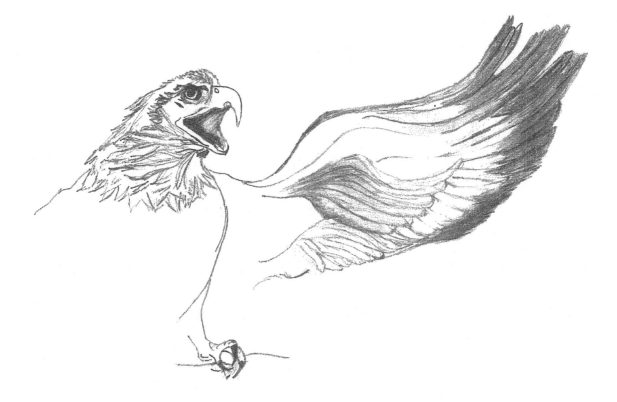

COLOR THE EAGLE.
IMAGINE IT FLYING.

# "HE IS MY STRENGTH"

He is my strength
He is my hope
He is my rock
My fortress
He is my all
He is my God
I worship Him

I worship You
Oh King of Kings
That is what I'll forever do

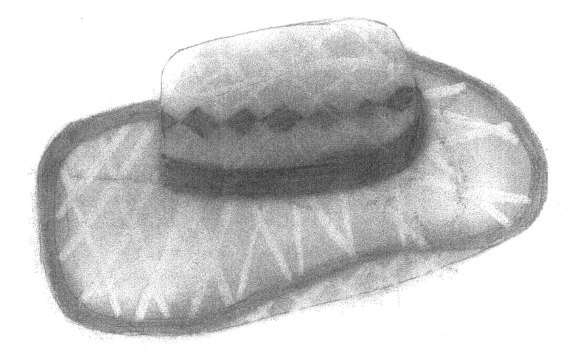

COLOR THE HAT YOUR FAVORITE COLOR.
DO YOU WEAR A HAT SOMETIMES?
DO YOU THINK GOD NEEDS A HAT?

# "ALL THAT YOU'VE DONE"

When it's dark, God lights the candle
When I am dry, God fills my cup
When I am in trouble, God takes care of me
When I am lost, He tells me the way

He's the one true God
The only one that could do so much
Lord, I love You
For all you've done
All that you've done!

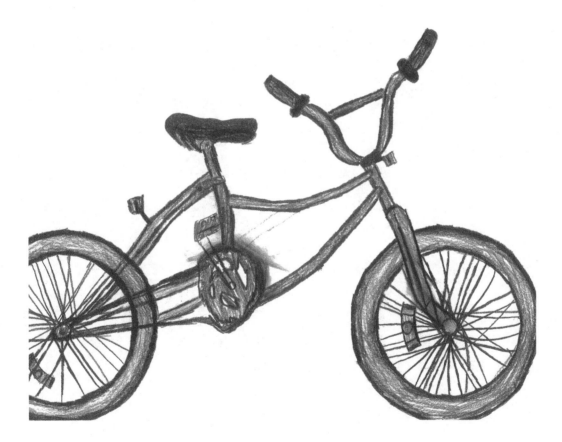

HAVE YOU EVER BEEN LOST
WHEN YOU WERE RIDING YOUR BIKE?
ISN'T IT GOOD THAT GOD HELPED YOU
FIND YOUR WAY HOME?
COLOR THE BIKE PINK OR BLUE.

ALL THAT YOU'VE DONE

# "HE GUIDES ME"

The Lord is my shepherd
He shall guide me
As I walk He abides with me
I follow His footprints and His path
He will show me the way and
Someday I will go to His home to forever stay.

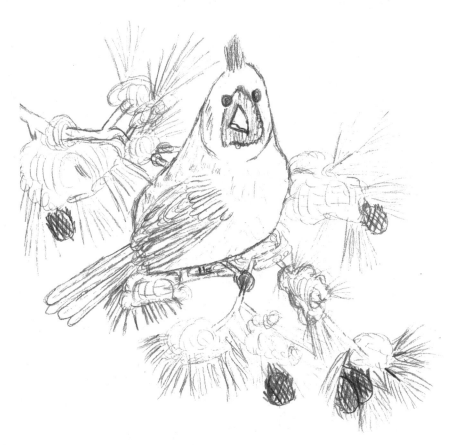

Cardinal                                    11 yrs. M

DO YOU THINK THAT GOD HELPS THE BIRDS TO FIND FOOD?
COLOR THE BIRD RED.
A RED BIRD IS CALLED A CARDINAL.

# "GOD LOVES ME STILL"

Sometimes I complain or disobey
Sometimes I get in dismay
But God loves me still

Sometimes I get in trouble or start to grumble
But God loves me still

Sometimes I plain do wrong
But God loves me still.

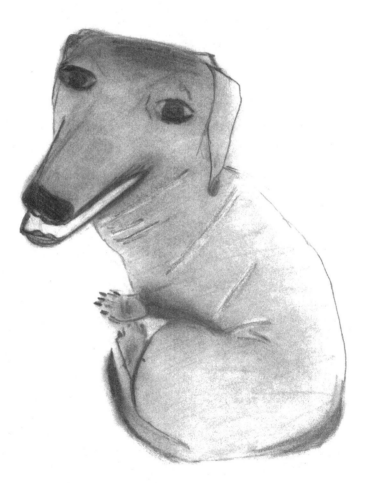

DOES YOUR DOG EVER DISOBEY?
YOU STILL LOVE YOUR DOG EVEN WHEN HE/SHE IS BAD.
COLOR THE DOG.

# "DO YOU BELIEVE IN ANGELS?"

Do you believe in angels dressed in pure white?
There are halos above each head
Guiding you at night.

IN THE SPACE PROVIDED BELOW DRAW A PICTURE OF AN ANGEL WITH A HALO.
THEN DRAW A PICTURE OF YOUR FAMILY.
THE ANGEL AND YOUR FAMILY ARE HELPING TO GUIDE YOU.

"DO YOU BELIEVE IN ANGELS?"

# "DEAR GOD"

Dear God,
It is me, Natalie.
You love me and all the others, too.
We are the branches and You are the vine.
Amen.
Written by Natalie Mahne during church at the first grade level.

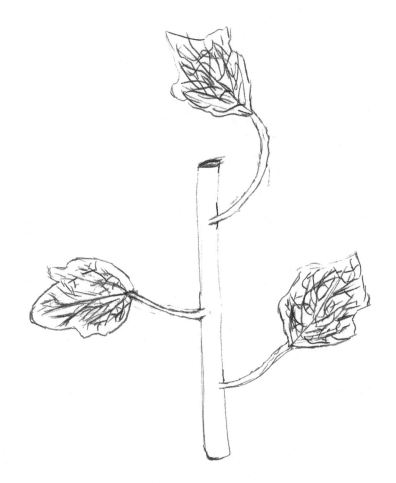

FINISH DRAWING LEAVES ON THE VINE.
WRITE GOD ON THE VINE.
PUT YOUR NAME AND NAMES OF FAMILY MEMBERS AND FRIENDS
ON THE LEAVES.
GOD LOVES ALL OF YOU.
COLOR THE VINE AND LEAVES VERY LIGHTLY SO
YOU DO NOT COVER UP THE NAMES.

# "I WANT TO MAKE A CHANGE"

We all have hopes and dreams that we hold tight
And only God can make them right.

I want to make a change in my life
And the way I can is with the help of God.
Can you help me?
I'm calling your name
Listen to me
I'm not ashamed that You came in my heart today.

I want to make a change in my life
I want to change the way I think
I want to change everything
I want You to be in my heart
In my heart.

ON THE FOLLOWING PAGE IS A PICTURE OF A SHIP AND A LARGE TREE.
COLOR THE SHIP AND THE TREE AND THE WATER.
THIS PICTURE IS SO PEACEFUL.
GOD WANTS TO GIVE YOU PEACE THAT IS EVEN GREATER AND BEYOND ALL
UNDERSTANDING.
YOU CAN BOW YOUR HEAD AND CLOSE YOUR EYES RIGHT NOW AND ASK HIM
TO CHANGE YOU AND
GIVE YOU PEACE.
GOD BLESS YOU.
AND HE WILL.

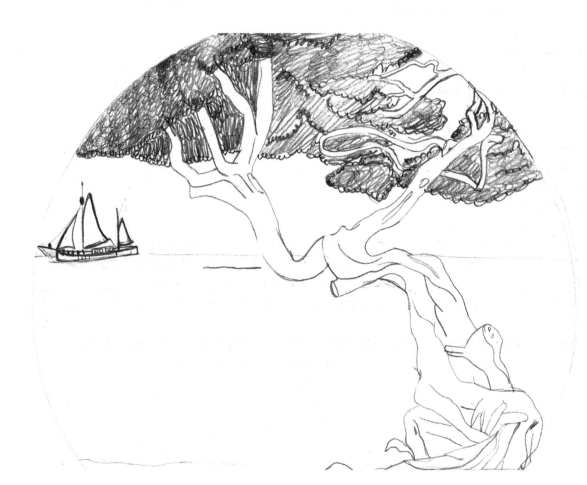